Which Ones Are the Terrorists?

الضفة الغربية.cam
[West-Bank.cam]

Conflict is unavoidable—we deal with it every day, with friends, and with enemies, and even in our own minds.

Which Ones Are the Terrorists? is a compilation of unscripted commentaries, collected from the West Bank and from around the world about the Israeli-Palestinian conflict, inspired by the prospect of peace in the Middle East, collected from the author's Web installation [West-Bank.cam] from 2000 until 2007, and includes 18 digital paintings by the author.

A short preface places the project in the context of the life of a working artist in New York City.

ANDREAS TROEGER

Photo: Garvey Rich

ISBN: 1440403201
IAN13: 9781440403200
Digital paintings by Andreas Troeger ©2000 | www.TechnologyArtist.com
Picture of author by Garvey Rich ©2007 | www.GarveyRich.com
Special thanks to Rachel Cohen | www.RaCoCo.org

[Introduction]—It was 1998 and I was in the West Bank of Israel, riding in the passenger seat of a car driving on an east-west route north of the Dead Sea. This angry-looking Israeli "Soldier Girl," as I called her, was in the driver's seat. She wore only a black tank top, Army shorts, and boots—the temperature inside the car was a scorching 90°F, very sticky—sweaty. The car had no air-conditioning, and we couldn't open the windows because of the desert sand. I had come to the West Bank to escape New York.

I arrived in New York City in 1992, and started working with international art superstar Nam June Paik and his assistant Mr. White, creating video art. Nam June had made a name for himself pioneering television and later video as art forms. Mr. White, always ahead of his time, too, was experimenting with interactive video installations. I was intrigued and wanted to learn a few tricks.

Mr. White and I worked the night shift at Post Perfect, a high-end post-production company in Manhattan, creating the video content for Nam June's installations. I settled in a studio apartment in the East Village where I could live and work on projects.

Mr. White and I started experimenting with the Internet and got a few Web servers up and running to promote our ideas, but we couldn't figure out how to make money from them. It was expensive to buy computers, pay the rent, and be an independent artist. Fortunately Nam June's gallery checks came in on a regular basis, which gave us some room for research and creativity.

Then, in 1996, Nam June suffered a stroke and couldn't work. This spelled financial disaster for Mr. White and me. We were on our own.

We wanted to use new technologies to make an extraordinary art piece that would also generate income. So Mr. White came up with a proposal. The idea was to establish an extended name-space on the Internet by creating additional TLDs (Top Level Domains) such as ".art", or ".film". People would be able to address their virtual content with [dot]anything. And they would be able to buy the names from us. This would expand the diversity of the Internet—and make us some money. So we formed Name-Space, Inc. I became head of programming and vice president of the company.

Wow—I felt like I was back doing what I'd been trying to get away from for the past ten years. I'd worked with mainframe computers in Germany but I'd quit after five years to be a filmmaker. I'd become very successful with my short films and art installations, which gave me the chance to come to New York and establish myself as an independent artist. Now, I was in bed with the same old tech crap I used to hate.

Of course, this was different. This was a once-in-a-lifetime chance to have some control over an important part of the Internet—the name-space. It was an assault on the establishment: in this case, on Network Solutions and IANA (Internet Assigned Numbers Authority, an entity that oversees DNS root zone management and other Internet protocol assignments). These companies, contracted by a

government agency, ran the show. This was big business. Clients paid up to $35.00 for a single domain name. Controlling the name-space meant power—and that's what human nature is all about. So is the Internet. I was up for the challenge.

My responsibility was to design and program all the interactivity. I used Unix systems, Perl, Macintosh computers, Apple Script, and PC hardware. We also had a "SUN"—a good old solid Unix box—that ran Solaris (a flavor of Unix operating system). I was responsible for the Web interfaces and the registry and management of new domain names and TLDs, including accounting and maintenance tasks. Mr. White's job was to make this a political and economic reality.

We needed the new names to work universally and not just within our extended special Internet, which was a technological/activist/avant-garde project in itself. In this virtual realm we used modified name-servers. These servers were under our control and carried, in addition to the traditional TLDs, the new ones, such as ".art", ".film", ".sex", etc., or country codes such as ".uk" or ".de", in their databases.

Two years went by and we established a solid system that worked flawlessly with almost no human interaction necessary—quite a little feat. It was a new model—a perfect, self-expanding, and self-maintaining system, a masterpiece. Mr. White waged a relentless PR campaign. The project enjoyed good name recognition within the online community and international press as an independent

activist/business project. In 1998, the project received an honorable mention from the Prix ARS Electronica, an art festival in Linz, Austria.

Then we sued Network Solutions and IANA for creating a monopoly on selling domain names. But everyone else questioned our motivations, thinking we wanted it all for ourselves.

I was starting to question Mr. White's motivations, too. He'd invested a lot of his own money to make Name-Space a reality and had hired a lawyer to represent the company in court. Then the lawyer skipped town and disappeared for good—taking his retainer with him. I went to one court hearing and it was a disaster for us—the court granted Network Solutions immunity because of its government contracts. I was certain that we'd never get a ruling in our favor. But Mr. White didn't see it that way. He wouldn't give up. Instead, he invested more money into a new law firm and appealed the decision.

Meanwhile, for me, the project was over. I'd worked with Mr. White for about six years by this time. I was starving and could hardly pay my rent. I'd never received any partnership papers nor did I make enough money to maintain my lifestyle, and I didn't see any means of future income from the project. I saw my independence slipping away, and I was not willing to go that route. I wanted to get back to filmmaking and video art. I had to get away. So I went back to Israel.

I'd met Soldier Girl on my first trip to Israel in 1991. It started when I showed my short film "Lifepak" at the Student Film Festival in Tel Aviv. I was also asked to serve as a student representative on a jury. Every day, I spent most of my time working, discussing, and evaluating other filmmaker's works, instead of getting laid and partying.

One good thing was that I met an American professor—the dean of the film department at NYU and very influential. He liked my film and encouraged me to apply for a DAAD scholarship to study in New York City. I introduced him to Soldier Girl. She told me later they got laid in his hotel room, so I guess we were even.

After the closing ceremony of the Festival, I'd planned to travel in Israel for a couple of weeks. It was my first vacation in a long time and I was looking forward to being by myself.

Instead, this German filmmaker from my school, who I didn't really know, insisted on accompanying me. We took the bus and occasionally Israeli soldiers came on board to search for Palestinian terrorists. We spent about a week checking out the country and wound up in a kibbutz by the Dead Sea. At dinner my companion vomited on my plate—I'd had enough. She couldn't take the desert heat, and I couldn't take her any longer. The next day we took a hike into the nearby hills and later boarded a bus back to Tel Aviv.

And now here I was, back in the West Bank with an unwanted companion—this seemed to be my destiny in Israel.

Soldier Girl was angry with me. A few days before, back in Tel Aviv, I'd had sex with her best friend. Soldier Girl and I had never had a romantic relationship, but she seemed to be obsessed with me. Whenever we hung out she demanded all my attention and was very possessive. Basically, she was a stalker. I had wanted to take a trip into the West Bank territories, and she managed to invite herself along.

We spent two nights by the Dead Sea, at a skimpy "campground"—basically a dirt hole. That was her idea of adventure. I thought it was her way of not spending any money on a hotel room.

She drove me toward Jericho, a town in the West Bank, in the Jericho Governorate, near the Jordan River. The name "Jericho" might have come from the Hebrew and Canaanite words for "moon"—the city was an early center of worship for lunar deities (who were apparently always fighting with the sun deities. Go figure).

On the horizon we saw a building and a huge parking lot. I asked Soldier Girl: "Is that a casino?" She said: "Yes. That's how Palestinians get money out of Israelis. Around 2,000 Israeli gamblers go there every night, because gambling is illegal in Israel, but not in the West Bank. There is not much else here. Look around. It's a desert. You can grow olives here—that's it."

We drove into the city. Soldier Girl parked the car with two wheels up on the sidewalk. The streets were very narrow. We strolled along close to the house walls. I felt very tense, like

gunfire could erupt any second, but it didn't. The marketplace consisted of a small roundabout with several storefronts around it. The buildings were two or three stories high. Across the street Soldier Girl spotted a falafel stand. She was addicted to food—always hungry—and it showed. Two young boys sold us the best falafel I ever had. We paid 50 cents.

We entered a small convenience store. I wanted to buy some coffee to bring back to my lover in Manhattan as a gift. The owner was praying and I had to wait for fifteen minutes until he'd finished and would sell me a 1/4 lb packet.

It was astounding how small Jericho was. Because of its historical significance, I had imagined Jericho to be a large, vibrant place. About 25,000 people live there now, but at the time it seemed like one of the small Bavarian villages I knew from my childhood, with 10,000-15,000 villagers at the most. According to archaeologist Kathleen Kenyon, who excavated the site from 1952 to 1956, the largest population that ancient Jericho could possibly have had was 3,000. The area of Jericho would have been a little less than two square city blocks back then.

I was surprised that such a small and visually insignificant place could have had such a big impact on international politics. It was then that I came up with the idea of putting up a web-cam—right there in Jericho, the heart of the West Bank. That would be a cool piece. There was a hotel where I could set up a computer with a dial-up connection, and monitor people's daily life and report about it. I figured I'd

need a few thousand bucks to pull it off. I spun the idea around in my head—I imagined myself as an I-reporter in the center of the action, ready when a new wave of violence erupted, which seemed inevitable.

But for now, I was trapped here with Soldier Girl. We were in a very non-English-speaking region—and she had the car keys. I felt a bit insecure. We visited a few more stores and bought some fruit. Back in the car we ate and then headed back toward Tel Aviv. We didn't talk much.

Back at her house we crashed early. I had to get up at 5am to catch my flight back to New York. We slept in the same bed, and when I got up to call a cab she hugged me and cried. I went to the airport and they frisked me—like they always do—the Israeli security girls in their uniforms.

Soldier Girl visited me a couple of years later in New York. She wanted to stay the entire time in my apartment. She even wanted to sleep with me in my bed, to have an "intimate moment," although she knew I was in a relationship at the time. I told her off and threw her out. That was the end of our relationship. I never saw her again. I didn't miss her, either.

Once I got back to New York, I told Mr. White I was leaving Name-Space for good. He was appealing the court decision, but his appeal was denied a couple of years later, and that was the end of the Name-Space project.

So now a piece about the Israeli-Palestinian conflict was on my agenda. I had no money. I applied for a few grants, but nobody would sponsor the Jericho web-cam idea. It would have to be another no-cost project. I decided to go ahead and do it anyway. And so in 2000, I launched [West-Bank.cam], a worldwide discussion forum on the Internet for users to speak out publicly about the Holy Land.

The site consisted of a feed from a web-cam displaying Jerusalem's Western Wall, overlaid by abstract animations of Arab countries and a discussion channel open to everybody on the World Wide Web who wanted to post a comment, in real time and uncensored. A ticker across the page displayed a single commentary, until a new entry replaced it.

The purpose of the forum was to raise awareness regarding the conflict between Israel and Palestine, a perfect example of the inability of countries to resolve their differences peacefully without breaking down into stalled negotiations and deadlock.

I wanted to give a voice to anybody who thought they had something to say about it. I didn't care whether people submitted their statements anonymously or if they signed them. What was most important to me was that there would be no censorship or moderation of any kind.

I had known I wanted to use an image of the Western Wall. I chose the wall as a symbol, not of worship, but of either confinement, or protection—depending on which side of the wall you were located. Growing up in West Germany in the

seventies, the wall between East and West Germany was a constant reminder of an imprisoned and suppressed society. I browsed the Internet for images and finally came across an Israeli Web site with an embedded image of the wall. I scrutinized the html code of the Web page and found that there was no wrapper protecting the URL of the web-cam image. A wrapper is a mechanism to prevent others from using a hyperlink. I could just copy and past the code into my virtual art piece. It worked. I had pulled a web-cam image of the Wailing Wall from an Israeli Web site—and they had no idea.

Their Web technology at the time wasn't too sophisticated; no one noticed that I was using the image for about two years, when they started analyzing their server logs and discovered that someone was squatting their signal.

When they found out, they redirected their web-cam, but I didn't care anymore. I just started using a still image of the wall stored on my own server, because it didn't really make a difference whether or not the image was live. I had made my point.

The comments were temporary; every new comment submitted would replace the current display. I collected every contribution in an archive, which is now this book—a reincarnation of opinions and reports about the region from 2000 until 2007.

An especially active period was in 2002 during times of turmoil in the West Bank. But once the public eye had shifted to the war in Afghanistan and later Iraq, the activity on the Web site slowed down, and it subsided almost completely in 2007. I decided then to take it offline.

*

[10/29/2000] On one hand, you have Israel acting like a spoiled, little child, who bullies the other kids on the block, and on the other hand, you have the Palestinians always acting like bad children with no manners. I put a curse on both their houses!

[12/29/2000] Get it together. The land belongs to God, the creator, Mohammed, whatever name you choose. Find peace or finish it off. Shake hands and build a country—one of creation.

[02/08/2001] They all must teach their children tolerance, to have a chance at a future—different from the past.

[02/21/2001] If you do not stand for something, you will fall for anything.

[03/09/2001] Isolate the area from weapon sales—and let the strongest survive. Jews rule Jews, Arabs rule Arabs.

[03/29/2001] Please stop the killing of innocent babies and helpless women—now!

[04/25/2001] They will never stop hating and killing.

[07/16/2001] Perhaps Israel needs another David!

[08/02/2001] They should both seek restoration by the living God and the commandments of God and Jesus Christ.

سه.الضفة الغربية

ISRAEL

[09/11/2001] Does this mean there will be war, with George Bush—of course!

[09/12/2001] Don't think peace will ever happen now!

[09/12/2001] Terrible is the only thing there is to be said.

[09/12/2001] When are we going to blow this useless piece of property (Israel) off the map for what they and their brethren did to our innocent citizens!

[09/17/2001] Let there be Peace!

[09/19/2001] America shall prevail!

[09/19/2001] Kill Saddam and Osama bin Laden.

[09/20/2001] Spare no one.

[09/24/2001] We know all Arabs do not support Bin Laden.

[09/24/2001] Let the holy commandments, of the living God and his Jesus Christ, be in all your hearts and souls.

[09/28/2001] I hope this issue can be resolved with peaceful communication.

[10/05/2001] Look what you do to your children.

سء. الضفة الغربية

WEST BANK

[10/05/2001] Sleep with one eye open! We're coming...

[10/05/2001] We'll be fucked.

[10/11/2001] Those who have done this deserve no mercy. Due process is swift execution in retribution for those who were murdered on September 11th.

[11/12/2001] I think Canada is doing a great job in helping the US and Arabs.

[12/24/2001] I hope the Jews kill Yasser Arafat. He's a troublemaker.

[12/26/2001] When will we embrace peace and accept all people?

[01/13/2002] Let us open our arms with love to all people, regardless of race or religion. Let us help one another and treat each other with respect and dignity. Let there be peace and freedom everywhere.

[01/13/2002] Let peace and freedom rule the world.

[01/15/2002] Peace will not come out of a clash of arms, but of justice lived.

[01/21/2002] Lack of perspective is what is instigating this digression of mankind.

سە. الضفة الغربية

OMAN

[01/29/2002] Arafat—You screwed your people! Murderer.

[02/01/2002] I am bewildered by all the senseless hatred and violence and in despair as to what to do.

[02/14/2002] If Israel were to disappear today, would that help the Arab countries with their problems one bit?

[02/18/2002] 20 years of oppression is certain to fill the Palestinian people with rage—there will be no peace until Israel ceases to exist.

[02/23/2002] After Israel has disappeared—the Arabs will start killing themselves.

[02/25/2002] Thou children of God, the eye which hath looked upon thee for harm and for evil; may God smite it down, and remove it from thy body...

[03/04/2002] If we justify war, it is because all people always justify the traits of which they find themselves possessed.
-Ruth Benedict

[03/05/2002] Oh! Small minds and hardened hearts, Greed & Fear shall be your doom...

[03/06/2002] War determines not who is right, but who is left.

سهع. الضفة الغربية

BAHRAIN

[03/14/2002] Dheisheh's (refugee camp near the city of Bethlehem in the occupied West Bank) entire civilian population is being subjected to the horror of Israel's military might. Every woman in the camp now does not know whether her husband will return home today or will be taken away. The detained 600 men have not had anything to eat or drink for the past ten hours. Nor have they been able to relieve themselves. The number of those who will be taken away remains unclear.

[03/21/2002] Peace: Freedom from war or civil disorder; harmony in human relations; tranquility, quietness. This should be the natural state of humanity, requiring no effort. Why is it not?

[03/22/2002] The intensity of the hate and the violence bewilders me—it is this way in all parts of the world—no one people are better or worse.

[03/26/2002] The Palestinians have said time and time again that the creation of a Palestinian state is part-1 of their plan; part-2 is the complete eradication of Israel.

[03/27/2002] It is a matter of trust! The sad thing is, that they don't trust each other. The even sadder thing is that they can't.

الضفة الغربية .ca

YEMEN

[03/29/2002] Kill the Arabs!

[03/30/2002] OK.

[03/31/2002] A plea from the Palestinians and the international witnesses to all of our friends abroad to immediately phone and/or fax your representatives and respective Governments to demand urgent and decisive action to stop Israel's brutal offensive on the Palestinian people.

[04/04/2002] Yesterday, they lifted the curfew for a while and as soon as people went out they started shooting. A 14-year-old boy and a father were shot in two different incidents while buying food when the curfew was lifted. UNRWA, Red Cross and Red Crescent are being shot at and have no access to the injured. I hope the American people wake up soon, as the terrorism inflicted on the Palestinians is coming straight from them.

[04/05/2002] This will escalate to Nuclear War.

[04/05/2002] Sharon is a mad man.

سه. الضفة الغربية

GAZA

[04/05/2002] The attacks here have intensified in the past two days. No one has slept in days. The attacks by the Apaches, tanks, M-16's, anti-aircraft missiles (aimed at buildings!) have been non-stop. My neighborhood has had non-stop gun battles since yesterday. We spent most of the night on the floor. The only thing giving people any hope here are the HUGE demonstrations happening in Rome, Paris, London, Belgium, Cairo, Beirut and Tunis.
-Amman, Ramallah (a Palestinian city in the Central West Bank)

[04/08/2002] When I first became politically active on the Left, I was confronted with people who were very ANGRY about the situation between Israel and the Palestinians, on both sides of the problem. Everyone would vent their rage without explaining what was going on there. I was completely uninformed about the situation and did not know how to go about informing myself. The anger was so intense from anyone I tried to talk to that I concluded, at that time, that I would just stay out of it. Why should I form an opinion if it meant that I would be filled with rage at everyone, and that others would hate me for my opinion? It's better to be ignorant, I thought at the time. Now I am reading about it. It's a lot of work to be inform, one must search beyond the mass media.

[04/09/2002] NUKE THEM ALL TO HELL—ARABS & ISREALIS ALIKE, GET RID OF THE WHOLE MESS!

[04/10/2002] Powell will fail.

[04/11/2002] I tried to leave Ramallah the day before but when I got to the checkpoint there was a line of Israeli soldiers shooting at the crowd, people were screaming and diving to the ground. No one was allowed out.
-Emily in Ramallah

[04/12/2002] We appeal to all artists of good conscience around the world to cancel all exhibitions and other cultural events that are scheduled to occur in Israel, to mobilize immediately and not allow the continuation of the Israeli offensive to breed complacency. Like the boycott of South African art institutions during apartheid, and the boycott of Austrian art institutions when Jörg Haider was elected, the art world must speak out against the current Israeli war crimes and atrocities.

[04/15/2002] As an individual human person I have the humanitarian duty, like all other human persons worldwide, to raise my voice and mobilize to the best of my ability against injustice and against the perpetration of war crimes wherever they may be committed.

[04/16/2002] Ah, let the damn Israelis and Arabs kill each other off... when WW3 starts, I'm gonna hole up in my bomb shelter and let the assholes blow it all up!

[04/20/2002] SHAME, SHAME, SHAME on ISRAEL!

[04/29/2002] Filled with despair and hate, you destroy yourselves and the others.

Which Ones Are the Terrorists?
West-Bank.cam — Andreas Troeger

سه. الضفة الغربية

QATAR

[04/30/2002] Do you know what its like not to be allowed out of your home for 20 days straight? To watch your child getting killed, because it was peeking out the window? To watch your home being demolished? To have your dead family members rotting inside your living room next to you while the Israelis will not allow any medical access or humanitarian aid to reach you? To watch Israeli soldiers kill people when they lift the curfew? To have soldiers enter your home destroy everything and steal all your money and jewelry? To be under constant bombardment by F-16's, Apache gun ships, tanks and machine guns? To be killed going to work? Crossing a checkpoint? Having absolutely no access to food, water or medical care? To watch people being crushed under the rubble of buildings being bombed—'indiscriminately? To listen to the Red Cross beg the Israelis to let them save 45 people trapped under the rubble of Jenin... who have been asking for help for over a week now with no food or water... and the Israelis still say no? While at the same time denying the massacre of innocent women and children? -Emily in Ramallah

[05/01/2002] Bibi was right: The correspondents are scared—they are S-C-A-R-E-D. They are scared to reveal the truth, scared that we might know the truth, know the extent of the horror that is taking place in our name, here, not in Sabra and Shatila, but here! What would we do with such awful knowledge—how would we live and sleep and how would we know a minute of tranquility when we think of the hundreds of Palestinian civilians who were killed just like that, with a casual release of the trigger, in the collapse of the walls of their houses from a tank shell, in the over-extended delays at the road posts where the soldiers operated according to instructions—always according to instructions.
-Idan Landau's speech 27th of April rally in Tel Aviv

[05/02/2002] Do you understand the magnitude of the current crises? Are you not following any news? Have you not heard that Israel is NOT allowing any human rights groups, or any humanitarian aid into the West Bank? That they have enforced a media blackout? That they are arresting and shooting Journalists? That massacres are occurring all over the place? That Israel is in violation of humanitarian law, international law and the Geneva Convention?
-Emily in Ramallah

[05/04/2002] Palestinian leaders say the suicide bombers have no choice because they are so desperate, so degraded, and so hopeless. Israeli leaders say Israel has no choice but to root out the terrorists. On both sides, each time, we climb to a higher level of violence, and sink to a lower level of inhumanity. -Etta Prince-Gibson, Jerusalem

[05/07/2002] Huh?

[05/08/2002] I wish the world ended so that everyone can be at peace.

[05/08/2002] Arafat must go.

[05/09/2002] Hummus—not Hamas.

عـه. الضفة الغربية

LEBANON

[05/10/2002] America loves a good genocide! Hey, pass the popcorn!

[05/11/2002] All wars are wars among thieves, who are too cowardly to fight and who therefore induce the young manhood of the whole world to do the fighting for them.
-Emma Goldman, 1917

[05/11/2002] Kill all the Arabs! —Then we will have peace!

[05/12/2002] Sometimes, peace can only be achieved by war. The problem in Israel can only be resolved by an all out war between Israel and the entire Arab world. The Saudi Peace Plan is absurd and would mean the end of Israel. Israel simply cannot survive if the Arab population within its borders surpasses the Jewish population. As it stands now the Arabs make up 20% of the Israeli population—if the right of return provision of the Saudi So-Called Peace Plan were enacted, the Arabs would soon outnumber the Jews. You don't have to be a genius to figure out what would happen then: Israel would cease to exist, which is why Hamas (a Palestinian terrorist organization) supported the Saudi Plan. There is no denying that fact no matter what your perspective on this conflict. Clearly, only a war can end this dispute.

[05/13/2002] NEVER EVER A JEW WANTED PEACE. READ HISTORY AND YOU WILL FIND OUT, NO WONDER JEWS ARE HATED.

[05/13/2002] We are teaching the children that suicide bombing is the only thing that makes Israeli people very frightened, said Islamic Jihad member Mohammed el Hattab, a teacher in a training camp. Furthermore, we are teaching them that we have the right to do it. We are teaching them that after the suicide attacks, the man who makes it goes to the highest state in paradise.

[05/13/2002] Qweww.

[05/13/2002] If Palestinians and Arabs had some legitimate way of expressing their grievances to the US who is harming them, I don't think the terror of 9/11 would have happened.

[05/16/2002] We are all God's children.

[05/17/2002] These nuuuuuuuts!

[05/22/2002] The war is no longer confined to the Middle East, but spreads across the world. There are difficult times ahead of us. Woe, woe...

[05/30/2002] There will never be any acceptance for anything righteous from a Muslim, as righteousness for them can only be obtained through the lying murderous eyes of their false prophet Mohammed. We may as well declare all out war, for the west will never accept the darkness of that 7th century despot! Support Israel, keep posting!

[05/31/2002] There is too much hate to make peace now.

[06/01/2002] How Bush came to power, and how Bush deceives Americans into war: THE SATAN HAS RISEN. And the fact is stated Bush will reign 40 & 2 months = 3 years and 4 months after that Bush will be exempt of all his power. God's will to be imposed upon the dark shadow president.

[06/04/2002] The holiest city of Islam should be turned to dust. It is the originating source of the greatest threat to world peace in the 21st century. It is here that Moslems energize their perverse faith and hatred for non-believers. Moslems believe that the security of Mecca is protected by heaven. Therefore, its destruction would go a long way in showing the powerlessness of Allah, and in undermining the authority of the Koran with its wicked reactionary militant belief system.

[06/06/2002] I dream of the day when I'll open the newspaper and read a headline saying something like: "Palestinian Police Arrest Six Israeli Gunmen." When will the fantasy and delusion most Americans are living under end? When will we see clearly that the Israelis are murderers and rapists? Cut all money to Israel now, then we'll see how the Israelis do against the Palestinians when they're not sitting in the comfort of an American made F-16!

سه. الضفة الغربية

SYRIA

[06/09/2002] Which ones are the terrorists?

[06/11/2002] Sharon and Arafat can kiss my white American A$$ b/c they don't deserve any respect! All scumbags in the Middle East!

[06/13/2002] And ye shall hear of wars and rumors of wars: See that ye be not troubled: For all these things must come to pass, but the end is not yet. -Matthew 24:6

[06/15/2002] The last thing I saw when I left the Jenin refugee camp this past April was a large black flag placed triumphantly atop a heap of ruins at the camp's entrance. It was the flag of Islamic Jihad. If there was any sign that Sharon's military blitz into Jenin had been an utter failure, this was it. All the might and ferocity of the Israeli military machine cannot crush the Palestinian uprising.

[06/18/2002] The Muslims will never stop trying to kill every Jew/Christian on the face of the earth. They simply will not stop until they have pleased Satan. They are very evil Luciferians. They believe they are worshiping God, however, they are really worshiping Satan. They dwell in bitterness and unforgivingness. The curses are coming down their family line for rejecting Jesus Christ.

[06/20/2002] The state of Israel should have never been formed after WW2 to accommodate the displaced Jews of the world. What should have happened was the countries of the world should have been forced to take back their Jews and restore all that was taken from them, not take from the Palestinians.

[06/20/2002] When Aisha was about four-five years old Muhammad started dreaming of a union with her and he wasted no time in realizing this, in spite of the fact that object of his dreams was a mere child. Perhaps you want to assume that it is normal for a 50+ year old man to dream of marrying a four- or five year-old child, and then actually ask for her hand at six? Is it normal for an oversexed old man to dream of a union with a four- to five-year-old GIRL? (Muhammad had over nine wives and concubines)

[06/22/2002] I believe that if Israel didn't exist, these terrorists would hate the US anyway.

[06/23/2002] All this crap about peace is not working. So the Biggest Baddest Bastards (BBB's) will win. So I guess Arafat better pack his bags along with his whinny crew!

[06/25/2002] Fighting is obligatory for you, much as you dislike it. But you may hate a thing, although it is good for you, and love a thing, although it is bad for you. God knows, and you do not... idolatry is worse than carnage.
-Holy Quran, Sura 2:216

[06/25/2002] The only time there will be peace is when the Arab oil is finished and the world has no more interest. Like Africa, no one cares about the atrocities there. When the Europeans and even America has no more interest in Arab oil, Israel will be free to show its mighty power, without interference of the world.

[06/28/2002] Bush's plan going to bring more suicide bomber—and maybe the end of Israel.

[06/30/2002] Assassinate Sharon! This bloodthirsty killer must be stopped! This bloodthirsty killer must be killed! Is there no Arab country that has the honor and integrity to drive Sharon either to death or to the sea? Put Israel back into the pas.

[07/02/2002] Arab Muslim Terrorist: We're going to kill all of you, even if we all have to die doing it. This where it belongs!

[07/09/2002] Palestinians—Stop throwing rocks and get a job.

[07/10/2002] You call this a war, ha, ha, ha, ha—don't make me laugh. Mad bombers women, children and tanks roll in then roll out. A war is when you go in and take over the other country; a war is when you battle day in and day out. Please don't call it a war; it gives the word war a bad name. I see it as a joke. Arabs don't know how to fight. They have all this money from oil to buy weapons and put on parades and their own people are starving, sick, no schools, and brainwashed by morons. Name me one Arab war hero and not one that blew him or herself up that's a fool.

[07/12/2002] What every racist wants—his own little homeland—bankrolled by USA taxpayers.

[07/19/2002] I bron agin chrastian, Jesuz hates Clintone and Hilreey Clintone... blu dress wit stanes and gooy stuf on it only chrastian gone to haven! Blessd o irsael... jesuz faVOrit choosen poople God love jew wit all his hart! We must giv all jew our munny! Aman! *-A Chrestjun*

Which Ones Are the Terrorists?
West-Bank.cam — Andreas Troeger

الضفة الغربية .ca

SAUDI ARABIA

[07/23/2002] The dumbing down of America has never been more evident than on these message boards. The political correctness and lowering academic standards of the past ten years has created political ignorance, social incompetence, and moral dysfunction to a frightening and disgusting degree. God bless Israel, the USA, the GOP and to hell with everyone who disagrees!

[07/25/2002] One of the daily deadly perils in Jenin is the constant confusion over curfew. Although curfews here are usually announced on television and radio late the night before, the Israeli army is notorious for changing its mind with little or no warning. This has proven deadly, because the Military has a habit of declaring curfew in Jenin by means of driving through the town and composing loudspeakers punctuated by heavy fire aimed directly at civilians.

[07/26/2002] Families are broken by the deaths of loved ones and the imprisonment of Jenin's young men, fathers, brothers, and sons, held indefinitely in administrative detention without charge. Ambulances have been fired upon this week and continue to be held for long periods at checkpoints while emergency patients await treatment. Two journalists were recently shot, one killed and children are fired upon routinely.

سـع. الضفة الغربية

CYPRUS

[07/28/2002] American ambulance brigades are forming to help the hundreds of civilians who are bombed daily by the Israelis. The brigades will assist non-combatant Palestinians to receive medical help. Also, it might help deter Israeli offensive forces from bombing {with American bombs and weapons} American volunteers who are working to save the lives of innocent people. Moslems and Christians must unite and help to defeat the Israeli forces—forces of darkness and death.

[08/01/2002] BOTH Sides are Guilty of MURDER and MADNESS!

[08/02/2002] Anyone that thinks outside intervention from other regions in the world is going to stop their constant killing of each other is as mad in the head as they are! Let the hate stay in the Middle East and support its self-destruction. Anyone from the outside nations that do interfere will only become as hated as they hate each other in the Middle East and these mad people THEN will turn on you and want to blow you away. The best solution is to encourage them to kill each other—and do it quickly.

[08/04/2002] Nothing good or desirable is coming from that region. If you think oil is good—you are wrong. Oil is a pollutant. The whole Middle East is full of polluted people and products. Nuke the region and let's move on. While we are at it—nuke the Vatican with the Pope in it, too!

الضفة الغربية.ca

EGYPT

[08/07/2002] Eye for an eye religions are outdated. They are a crime to humanity.

[08/09/2002] Saddam is trying to sucker Bush into a war. Don't do it GW Bush; Saddam knows if America commits to a Middle East war, it will only strengthen Saddam's hand. A war will only bring the terrorists together in unification and toughen their resolve.

[08/11/2002] As a good democrat afraid of my shadow, I think we should let Saddam attack us first. If he does manage to kill a few hundred thousand Americans, then we will have a reason to attack him. If he doesn't kill us first, then we can save that military money and give to minorities and Union special interests. Plus—we can always rely on the UN to save us. They are such good people up at the UN.

[08/12/2002] The Jews thrive and prosper in a multi-cultural and multi-ethnic USA. Why they don't create an Israel-Palestine state, which is multi-cultural, multi-ethnic with equal rights for everybody. Just create a mini USA, with a constitution and new set of laws. If the Jews are so confident and superior as they want us to believe; then they should have nothing to fear. They will dominate again.

[08/14/2002] Pray for peace.

[08/21/2002] A 15-year-old Israeli girl gets herself blown apart for standing at a bus stop. A 19-year-old Palestinian gets his head blown off for walking home ten minutes late. I'm tired of people saying: "They started it." Where are the people on both sides saying: "Let's stop it!"

[08/23/2002] American Indians need foreign aid more than Israel! Israel is hogging most of the foreign aid America has to offer. So look here, how about giving some of that aid to the American Indians, we are a foreign nation, too, lest you forget. And we need education, computers, schools, medical services and nursing homes. We are great people, with no hate for anyone, not even the Jews who are stuck with the great problem of trying to kill off all the Palestinians and make it seem like some kind of humanitarian project.

[08/31/2002] You stupid people are hurting children! And you will suffer eternal damnation for this! You stupid, stupid, stupid people! Stop this madness! Israel, get the hell out of other people's business! Palestine, teach and protect your children—before there are no children left to teach anywhere! You stupid, stupid, stupid, people!

[09/07/2002] Peace with Israel would force Arabs to face their rotten Governments—instead of always blabbing about Israel they would have to deal with their own rotten corrupt Governments creating societies with no future, rooted in the dark ages.

[09/12/2002] I am not going to worship whom you worship, and you are not going to worship whom I worship. To you, your religion and to me mine. -Qur'an, Sura 109:4-6

[09/18/2002] Five children killed in a playground by Jews, yesterday, and the news was almost silent.

[09/22/2002] Wake up and realize what's real, and what's just a dream. Peace would be nice... but... it ain't happenin' with the bastards in power... sooooooooo, war it will be!

[09/25/2002] Strangely, Arabs hate America, but they all want to live here or send their kids to school here.

[09/30/2002] Ordinary Palestinians and Israelis want peace and stability. However, it is the politicians and terrorists who are responsible for much of this mess. Getting rid of the terrorists is one thing, but the personal animosity between Sharon and Arafat has made the situation worse, and while they sit all fat and happy in their victim-hood, ordinary Palestinians and Israelis continue to suffer. Arafat, Sharon, and the terrorists, we need to get rid of the whole lot.

[10/04/2002] There must be a limit to hate. Peace in the Middle East will come when parents stop sacrificing the lives of their children for hate and revenge and instead sacrifice hate and revenge for the lives of their children.

سه.الضفة الغربية

IRAN

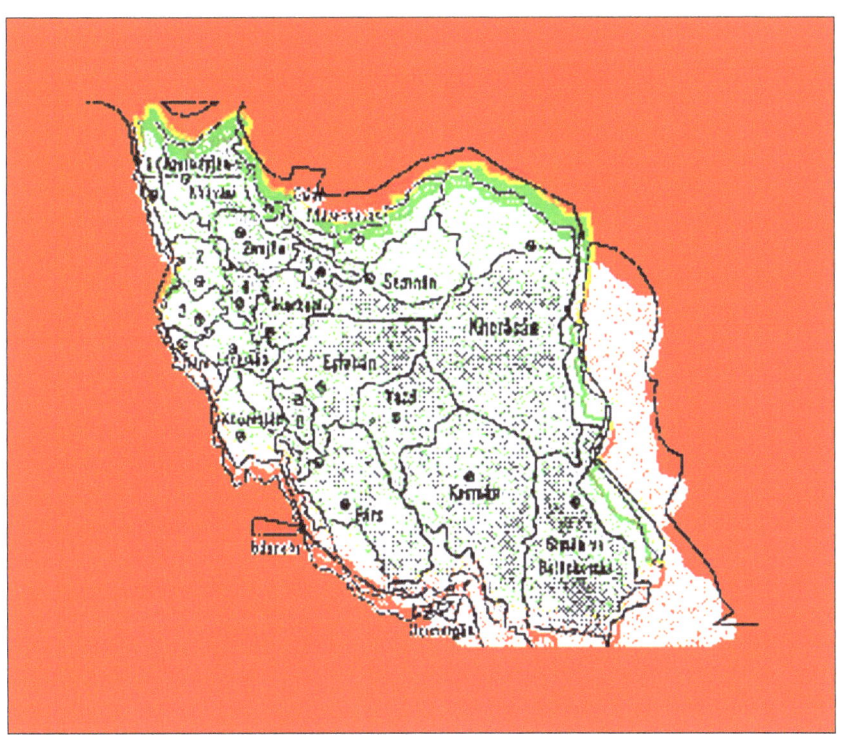

[10/08/2002] How terrifying it must be to be driving a tank and peering out at a twelve-year-old with a rock the size of a golf ball in his hand getting ready to launch it. "Shriek"—I imagine those poor innocent Jews in the tanks, who are no doubt praying aloud for the war to stop and apologizing whole heartedly for killing Jesus, are just nearly senseless with fear and suspense as to whether they may someday stick their heads out from the tank top and get beamed with a stone on their US supplied helmets.

[10/14/2002] I am appalled by the hawks and disgusted at the doves.

[10/16/2002] I wonder that the son of the man who torched the oil fields can bring himself to do it all over again, can think it's a grand gesture, can conscience the death of more women and children in the aftermath of what is only boys turned into men and again playing with tanks and guns again, snuffing the life out of joy again, taking things too far when there are other better options other better ways other better scenarios other better ways to see one's name appear in History books. -Carla Cryptic, California, USA

[10/23/2002] When the dust clears and the war ends—will anyone trust America? All great civilizations fall. Is this the beginning of the decline?

[10/27/2002] Upon the sunny desert—there falls no rain—only tears—of blood and pain. -Sztuka Fabryka, Belgium

[11/03/2002] Stop murderer's hand; refuse the power sowing death, there, where innocent eyes search the sun to begin to live. Open yourself, nailed heart, let the light filter from love fissures, bringing future to undefended arms, no graves, no crosses. My body trembles, it rejects innocent blood, while it receives with joy transfusions of peace and life.
-Anna Boschi, Italy

[11/08/2002] Merciful God, pick yourself another people for a while. We are sick of death and dying. We've run out of prayers. Pick yourself another people for a while.
-Kadia Molodowsitzy

[11/10/2002] We've no blood left to be victims. Our home has become a wilderness. Our land cannot hold any more graves. For us there are no unsung dirges. Not a single unveiled lament in our ancient books.
-Kadia Molodowsitzy

[11/12/2002] Merciful God, sanctify another land, another mount. We have covered every field, every stone with sacred ash. With the old, and with the young, we've paid with infant lives for every letter of your ten commandments.
-Kadia Molodowsitzy

[11/13/2002] Merciful God, lift your fiery brow, and consider the other nations of the world. Give them the prophecies and the days of awe. Your word is babbled in every tongue. Teach them the deeds, the paths of trial.
-Kadia Molodowsitzy

Which Ones Are the Terrorists?
West-Bank.cam — Andreas Troeger

سـe.الضفة الغربية

UNITED ARAB EMIRATES

[11/15/2002] Merciful God, clothe us in simple garb—of shepherds, of blacksmiths at the forge, of washerwomen and of tanners, and of other lowly callings. And one more kindness we ask of you: Merciful God, take from us the aura of greatness. -Kadia Molodowsitzy

[11/18/2002] Why should fear, killing, destruction, displacement, orphaning and widowing continue to be our lot, while security, stability and happiness be your lot? This is unfair. It is time we get even. You will be killed just as you kill, and will be bombed just as you bomb. And expect more that will further distress you. -Osama Bin Laden

[12/01/2002] If you take the field of an enemy, the enemy will come and take your field. -Ancient proverb from Mesopotamia

[12/03/2002] Be gentle to your enemy as to an old oven. -Ancient proverb from Mesopotamia

[12/11/2002] The biggest threat to our safety and the general safety of the world is our own President Bush, he is urging and encouraging war, he will stop at nothing and I fear that he really just wants to play with his toys, to use and demonstrate the mighty power of the U.S. Military—why not use the mighty power of the U.S. to instill faith and hope in humanity, not hide behind trickery and force, give peace an honest chance. Maybe if we cut the military budget and gave it to our educational system we would find an easier and more peaceful way to deal with this situation.

[12/14/2002] Peace? —Nobody's interested!

[12/16/2002] We have no time to recover from one blow, and then comes another one, stronger. It's better to have a war. Better war than a drop here, a drop there. Better for them, too. What we have now is worse. -Tippy Ankari (at the funeral of two Israeli boys killed in Kenya)

[12/16/2002] What hope is there?

[12/20/2002] (I sincerely advise) to set fire to their (the Jews') synagogues or schools and to bury and cover with dirt whatever will not burn... I advise that their houses be razed and destroyed. -Martin Luther, On the Jews and their Lies, 1543

[12/21/2002] If that is going to be the way they continue through the weeks ahead, then we're not going to find a peaceful solution to this problem. -Secretary of State Colin L. Powell, saying Iraq lied about weapons programs.

[12/23/2002] Peace on Earth, Goodwill toward all living beings.

[12/25/2002] Peace and Love.

[12/26/2002] In life, sorrow tends to last just a little longer than joy. So we try to just touch the joy to alleviate the sorrow. -Abdul Razak Al-Alawi, a founder and conductor of the Iraqi National Symphony Orchestra.

Which Ones Are the Terrorists?
West-Bank.cam — Andreas Troeger

‎‫عه.‬ ‫الضفة الغربية‬

KUWAIT

[12/30/2002] Please sit quietly and look for a peaceful solution to all our problems—personal and political...

[12/31/2002] Let's give a toast to 2002; it wasn't as nearly as bad as we feared it would be! Goddess, give us mercy this coming year.

[01/03/2003] I believe that if those calling for war knew their children were more likely to be required to serve—and to be placed in harm's way—there would be more caution and a greater willingness to work with the international community in dealing with Iraq. -Rep. Charles Rangel

[01/05/2003] Every day of war is a day that I cannot see my mother.

[01/08/2003] Give me some voice to shout to the World: No war! No war! No war! -Ricardo Alfaya, Rio de Janeiro, Brazil

[01/14/2003] Those who sent the soldiers to war, don't they taste blood in their mouths? The mouth, which speaks in favor of war. Don't they taste the bitterness of blood in their mouths? Those who told them to pull the trigger, don't they smell the mud of the bodies on the ground? Those who defend war don't scream. Don it scream in pain, don it have love for life. -Douglas Carrara, Rio de Janeiro, Brazil

[01/21/2003] How can I go forward when I don't know which way I'm facing? How can I go forward when I don't know which way to turn? How can I go forward into something I'm not sure of? Oh no. Oh no.
-John Lennon, how? 1971

[01/21/2003] There is no reason to go to war while we can still improve the path of cooperation. We don't believe the world is ready. -Dominique De Villepin, France's Foreign Minister

[01/23/2003] GIVE PEACE A CHANCE!

[01/28/2003] There will be no political peace until we, each one of us as individuals, make peace in our own hearts. I call upon you to begin to do so now.

[01/30/2003] If your enemies are hungry, feed them.
-Romans 12:20

[01/30/2003] No end—war end—happy end.

[02/10/2003] Violence is the refuge of the incompetent.
-Isaac Asimov

[02/14/2003] Tell the world Americans are demonstrating for peace!

[02/18/2003] War is not inevitable. Force should only be used as a last resort.
-Statement on Iraq by the 15 European Union Nations.

[02/18/2003] There is no end to war... it is always among us... we are worse than animals...

[02/23/2003] Ignorance leads to fear; fear leads to anger; anger leads to violence; violence leads to war...

[02/28/2003] Not knowing each other leads to misunderstandings to suspicions to fear to hate to war knowing each other leads to understanding to acceptance to compassion to love to peace.

[02/28/2003] It's only when we realize that we are the Jews inside each Palestinian and the Palestinians in each Jew—that we can start a process of love instead of hate and self-hate and achieve peace.

[03/07/2003] The origin of all wars is the pursuit of wealth, and we are forced to pursue wealth because we live in slavery to the cares of the body. -Plato, Phaedo

[03/09/2003] But whosoever forgoeth revenge, it shall be expiation for him. -Quran 5:45

[03/15/2003] Evil Bush starts a war that will destroy innocent lives and the reputation of the USA.

[04/08/2003] It's a little sobering. When you're training for this, you joke about; you can't wait for the real thing. Then when you see it, when you see the real thing, you never want to see it again. -Capt. Sal Aguilar (after a battle near Baghdad, standing in a field with dead Iraqis all around him)

سهء. الضفة الغربية

JORDAN

[04/15/2003] Your tax dollars support war.

[04/16/2003] E-Bay rules.

[04/27/2003] The newspapers are filled with lies. No one is allowed to tell the truth.

[05/07/2003] The more aggressively we use our power to intimidate our foes, says Kiesling, the more foes we create and the more we validate terrorism as the only effective weapon of the powerless against the powerful.

[05/26/2003] The moment has arrived to divide this tract of land between us, and the Palestinians.
-Ariel Sharon, Israeli Prime Minister

[05/30/2003] If I had known, Hiba, that you were going to do this, I would have tied you up with a rope.
-Fatmeh Daraghmeh (mother of a Palestinian suicide bomber)

[06/12/2003] So what do we do now—oh tell me! Every time there is a line of hope, we get socked in the teeth.
-Esther Lapian, 53 (after a bus bombing killed 16 in Jerusalem)

[06/22/2003] Aw, just nuke the whole goddamn Mid-East, the bastards deserve it!

[06/27/2003] There's no way out of this... it's gone on for so long, there will never be an end to the conflict... I have no hope...

Which Ones Are the Terrorists?
West-Bank.cam — Andreas Troeger

الضفة الغربية .cam

IRAQ

[07/07/2003] Can you imagine not being able to leave your house for days, because you might be shot?

[07/17/2003] Has there ever been peace anywhere?

[07/19/2003] Jews and Muslims have so much in common, why must we fight? We believe in the same one God. Why can't we share the Holy Land?

[07/23/2003] The Israeli security forces have a light trigger finger when it comes to Arab-Israeli citizens.
-Ahmed Tibi, Arab member of Israeli Parliament

[07/24/2003] O Controller of the hearts, make my heart adhere firmly to Your religion...

[07/25/2003] I can't imagine this President supporting a state of terrorists, a sovereign state of terrorists...
-House Majority Leader Tom DeLay

[07/31/2003] Who bears the burden of peace? Who is responsible?

[08/20/2003] The cultures of violence and destruction have been relentlessly pushing on for thousands of years. They will stop only when they collapse from the pressure of their own weight. What is going on in the Mid-East today is nothing new; there has been repression and murder for thousands of years.

سء. الضفة الغربية

TURKEY

[10/11/2003] I feel nothing but despair in this situation.

[11/07/2003] This conflict will continue for generations.

[11/11/2003] Good people can defeat extremists.

[11/21/2003] He displays the power of his hand, that thou may know his might.

[11/23/2003] Does it take a terrorist to keep Palestine in the US news?

[12/15/2003] Since when is anything peaceful news? The news media thrive on violence wherever it happens.

[12/17/2003] Is it our sick culture that we find news of violence so entertaining?

[12/20/2003] Must anger make love lost?

[08/01/2004] Fear and hate is a vicious cycle.

[08/08/2004] I am so sad. It just hurts.

[08/15/2004] Shame, shame, Oh Israel!

[08/27/2004] Face your fears.

[10/08/2004] Peace is a matter of opinion, but also a categorical necessity.

[10/15/2004] The situation is a disgrace for the Americans, who have thrown in there, a lot with the Jews and by doing so, have placed the security of everyone in jeopardy. They should have invaded Israel and ordered them to make a proper permanent peace pact with Palestine. Had they done this, the world would now be on its way to peace instead of mayhem.

[11/03/2004] Mutual understanding at the basest of levels- beyond ego, possessions, and the political machine—therein lies the key.

[11/11/2004] Four more years of disaster in the Mid-East, thanks to U.S. voters!

[12/02/2004] Four more years of HELP! In the Mid-East, thank you U.S. voters!

[01/16/2005] COLD, COLD—YOUR HEART!

[01/20/2005] Yikes.

[09/14/2005] Lord Jesus let YOUR will be done!
P.S. Please come soon…

[09/25/2005] Damn, Dirty Apes!

[01/30/2006] Keep on rocking in a free world.

[03/29/2006] Peace already… Jesus Christ… oops, that's what started it… damn.

[01/16/2007] Imagine peace—act to create it!

[01/16/2007] We are all God's children.

[01/16/2007] Pro Palestine, Pro Israel—Anti-Hate, Anti-War.

[01/16/2007] The creators of the war machine need conflict in order to sell weapons. It's a trillion dollar business.

[End of story]

www.ingramcontent.com/pod-product-compliance
Lightning Source LLC
Chambersburg PA
CBHW051026180526
45172CB00002B/487